Under the Looking Glass

Under the Looking Glass

COLOR PHOTOGRAPHS BY

OLIVIA PARKER

INTRODUCTION BY

MARK STRAND

A NEW YORK GRAPHIC SOCIETY BOOK · LITTLE, BROWN AND COMPANY · BOSTON

This book was planned, prepared, and produced by the
Publications Department of Polaroid Corporation.

November 1983

New York Graphic Society books are published by Little, Brown and Company.
Published simultaneously in Canada by Little, Brown and Company (Canada) Limited.

Library of Congress Catalog Card Number 83-61445.
ISBN 0-8212-1556-6

For my husband John
and my children John and Helen

with special thanks to Varujan Boghosian

Introduction

Olivia Parker's photographs contain a remarkably suggestive world of particulars—so suggestive, in fact, that we are not sure if we are looking at strange extensions of reality or colorful projections of dream. This is most marked in those photographs where a face or a figure is either receding into or emerging from the midnight of memory, as if we were getting the first or last (we are never sure which) glimpse of someone. But more often her photographs are of collages that assume the character of still lifes. Their flat, frontal aspect has been worked out so relations of color and shape remain as close to the surface as possible. They are meant to be looked at from top to bottom and side to side, very much as we look at nonobjective art, though clearly they are not nonobjective. On the contrary, they are filled with objects, but the space in which the objects exist is usually so shallow that the simple relationship between horizontal plane and resting figure, which we are likely to see in most still lifes, does not occur. For the most part, we have the illusion that we are looking down and into her photographs.

It is perhaps to compensate for this fluid feature of her work that Parker will indicate the fixed, ordered atmosphere of interiors. This projection of insideness is underscored by the use she makes of frames: the handle of a

clay pot frames an orchid, a worn wooden box frames a chambered nautilus —itself a series of internal frames—a drawn line frames a photograph of ocean, beach, and palm trees, a golden-crowned kinglet is framed by a frame, even pieces of mica, their edges catching the light, are used as frames. But these gestures towards establishing the lineaments of an interior domain only partially explain the power of Parker's photographs. It is in their eeriness, their dreamlike presence that they compel our attention most powerfully. They are like souvenirs from a silent kingdom. And though not *memento mori* strictly speaking, they possess a certain somberness that suggests Parker's fascination with the imagery that surrounds death.

In the introduction to her last book of photographs, *Signs of Life*, Olivia Parker said:

The living world seems to consist of fine balances
and thin edges: small variation with fragile structure,
delicate membranes, narrow temperature and pressure
tolerances. I like the implications of visual edges:
the swollen limits of a ripe pear touching a hard
line of light, downy feathers confined by a metal grid,
a mirror scattering its surfaces into nothing, or the
thin shell of a bright face, its edges already deteriorating
into darkness.

Her statement makes it clear why certain objects are preferred over others, holding out, as they do, the possibility for the most interesting, least expected,

combinations of color, weight, and texture. But it is precisely what Olivia Parker's objects do not do, or are not permitted to do, that gives her photographs such force. Because the unified surface of the photographs dematerializes the objects, and because the violence of random juxtaposition is controlled by their having been arranged for the camera, they cannot act on each other as they do in the real world. Their physicality is lost, and only their connotative or signalizing properties are left. They become suspended in an arranged pictorial reality and take on a remoteness we associate with dreams. The textural nuances of the living world may be alluded to, but in fact they are not present.

Unlike the collages we are most familiar with, Olivia Parker's do not take place on the surface, but under the surface. They seem to exist in the calm of another element and in them we experience the exposure of a world that is usually hidden, an underworld of fragments caught in a process of decline or decomposition. What supplies drama in Olivia Parker's photographs is not the tension between material and what it becomes, as in Cubist collage where newspaper, say, becomes a goblet, but the tension between the physical character of an object in the real world and its symbolic or imagistic character, as in Surrealist collage. What the critic Rosalind Krauss has said of Rauschenberg's paintings with objects in them is also true of Olivia Parker's collages; ". . . the image is not about an object transformed. It is a matter, rather, of an object transferred." Except that in Parker's work an object has been transferred to the calm, untouchable, still world of the photograph so that it is not the object, but the look of the object, not its materiality, but the illusion of its materiality, that we encounter.

This relocating of objects from the world into the glossy calm of the photographic image accords them an iconic stature completely at variance with their place in our everyday experience. This photographic designation of things as signs, of cast-off objects as images of permanence, amounts to a straightforward denial of mortality. In the real world flowers are perishable, but in Parker's world they are perpetually so, becoming the symbols of their own decay. Like Parker's other objects, they are irreducible in their power to describe themselves.

The planned or arranged nature of Parker's photographs also contributes to their air of permanence. The objects strike us as doubly fixed—first, by where they've been positioned in relation to each other, and second, in their being irreversibly caught by the camera lens. They are not decisive moments so much as they are decided moments. And they do not remind us of experience so much as suggest possibilities for revising experience. They are invitations to reverie. They remove us from fact into the fluid and resonant gradations of ambiguity.

Since Olivia Parker's relocated objects have relinquished their physicality and have not much to do with the real spaces they previously occupied, it is easy to claim they belong to the space of dreams or memory. Surely the inclusion of old photographs in her photographs (so we have a photograph of a photograph) emphasizes this degree of removal of actuality. Moreover, those photographed, though some are children, are somebody's ancestors, posed stiffly, sorrowfully for posterity. Even the fragment of writing, the only one that occurs in this collection, "Remember me when far off . . . ," directs itself to the issue of distance and reminds us how best to "read" the photographs.

Another aspect of these photographs that removes them from the everyday, but which contributes greatly to their beauty, is their color. The blues seem bluer, the pinks pinker, the reds redder, than we experience them normally. It is a dense, highly saturated color that would be remarkable on any object, but that seems appropriately part of the lush, heavy air of dream or memory. In such an atmosphere all objects are intensified—not to the point of transformation, but to a level where they share a talismanic quality. This shared power of objects creates an added tension in Olivia Parker's photographs. It is difficult for an object to assert itself individually, usurping our concentration, when the unifying compositional aspect of the work urges parity.

Though Olivia Parker's photographs have the capacity to endow objects with symbolic character, it is hard to know what precise meanings those objects have. (Parker herself has said, "I cannot explain the photographs.") But this is a quality that contributes to the fascination her photographs hold for us. They are both explicit in what they picture and elusive in how meaning is to be attached to what is pictured. What does one do with peaches that are ordinary in their plumpness but apparitional in their dark, subtly reflective surround? Or with mangoes that seem solid but seem also to float in an indefinite interior? Or, for that matter, with feathers, flowers, or garlic, mysteriously exiled to places where there is an abundance of red string and where old photographs seem to shine with a ghostly blue light? Unlike other photographs for which a story provides the "reading," Olivia Parker's must be read without a story. This accounts for a durational character of a wholly different sort than we ordinarily encounter with photographs. Instead of being reminded of a scene or an event, we are provoked into extending our "look" in

anticipation of achieving insight or discovering meaning. We are invited to invest each arrangement with a significance that would dispense with the reassurances that attach themselves to the levelling, democratizing effect of a glossy surface.

But not all our readings of Olivia Parker's work need be obscure or weighted with seriousness. There is another side to it that tends towards whimsy and humor, that capitalizes on incongruity. A yellow rose in full bloom is placed on a background of drawings describing vision in precise optical terms that cannot, for all their rigor, take into account the overwhelming presence of the rose. The skeleton of a chambered nautilus mocks, with its exquisite geometry, the clean but unexceptional geometrical drawings of the paper it rests on. A doll's head, a pouch, a starfish, a miniature pistol made for a charm bracelet, and an ominous beetle, vie with twelve delicate, fancifully illustrated antique playing cards carefully laid out in three rows of four. Sometimes the contrast is more subtle: strings of small beads form a dainty counterpoint to the strung–together bones in a sheet of anatomical drawings. Sometimes the contrast begs the issue of coincidence, as when three ragged lengths of feather blend into three nearly identical pieces of mica. But even when they are amusing, there is an irresistible poignance about Olivia Parker's photographs. Making use of the mottling and modifying properties of mica that can turn a new surface into one that seems tarnished, she will place a doll under a piece of it and the doll will appear ancient. Or, more simply, she will have a cut-out bird fly to a flower whose petals have already begun to fall.

Olivia Parker's photographs have the evocative power of dreams. In them, objects bathed with an eerie, luxuriant light transcend their ordinar-

iness and become the pleasing constituents of a vision that is both mysterious and highly ordered. These days, when we are convinced of the reality of a work of art or literature by how much violence it forces upon us, it is reassuring to come upon Olivia Parker's photographs, where the only violence is of the restrained or diminished sort and where power seems always the issue of delicacy. Her photographs are calm without ever ceasing to be suggestive and luminous without ever relinquishing their debt to darkness.

MARK STRAND

Plates

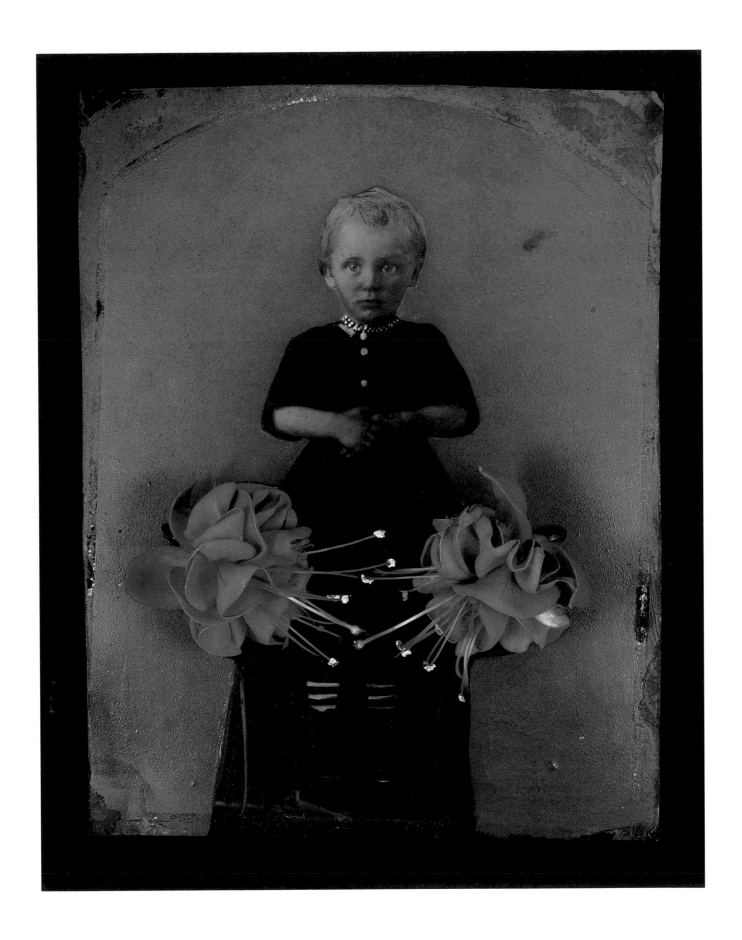

CHILD, 1980

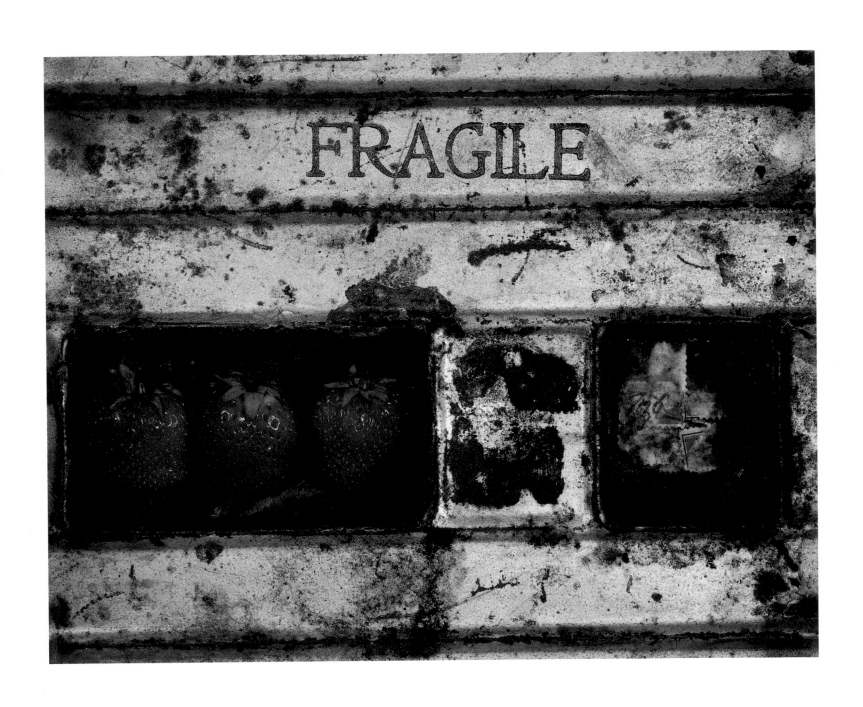

THREE STRAWBERRIES, 1978

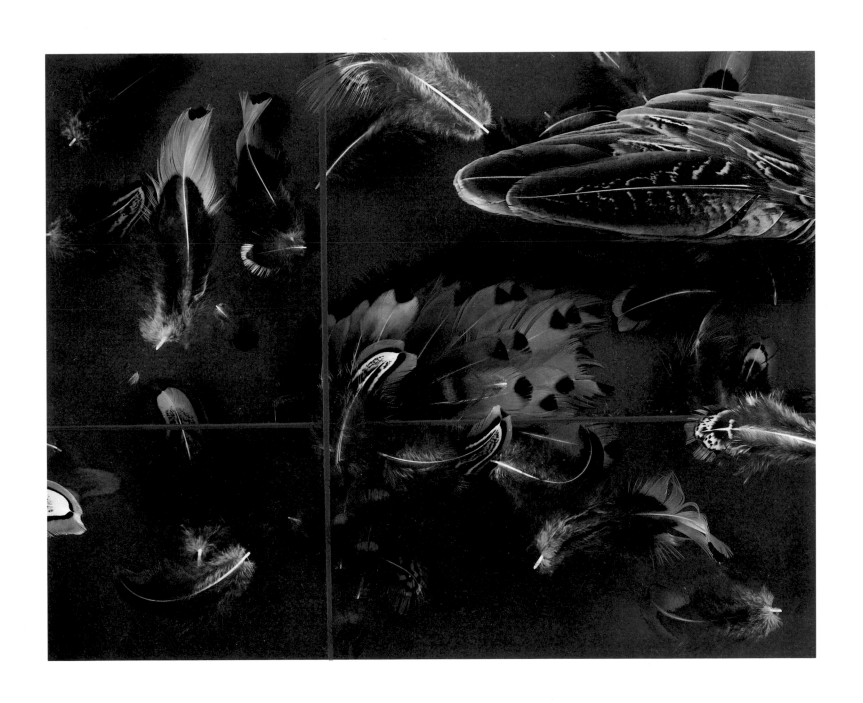

PHEASANT, 1979

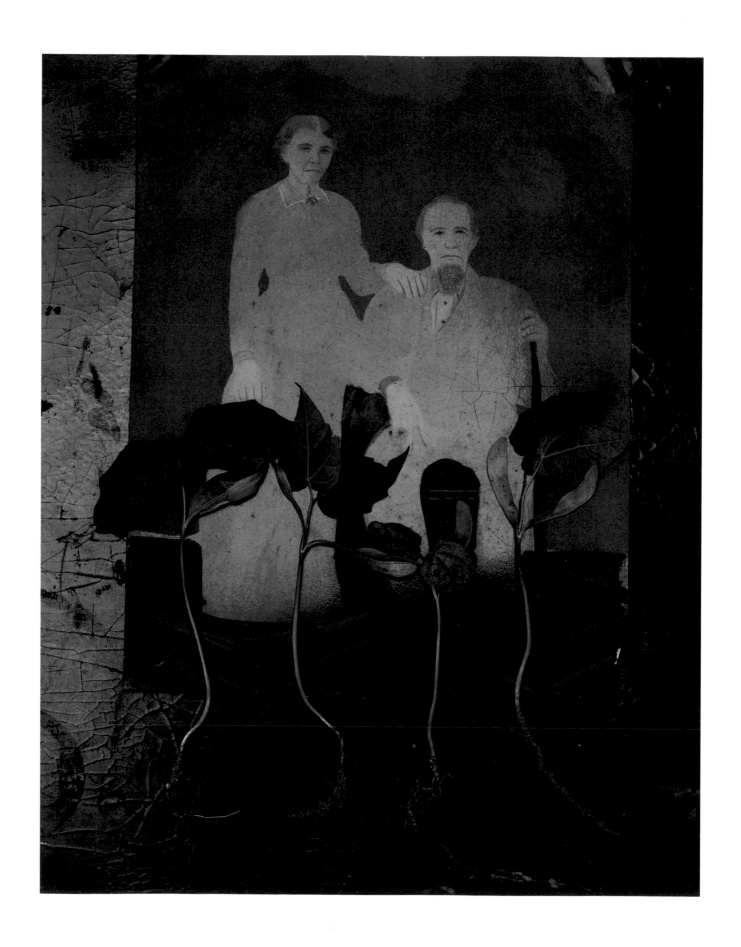

MAPLES, 1980

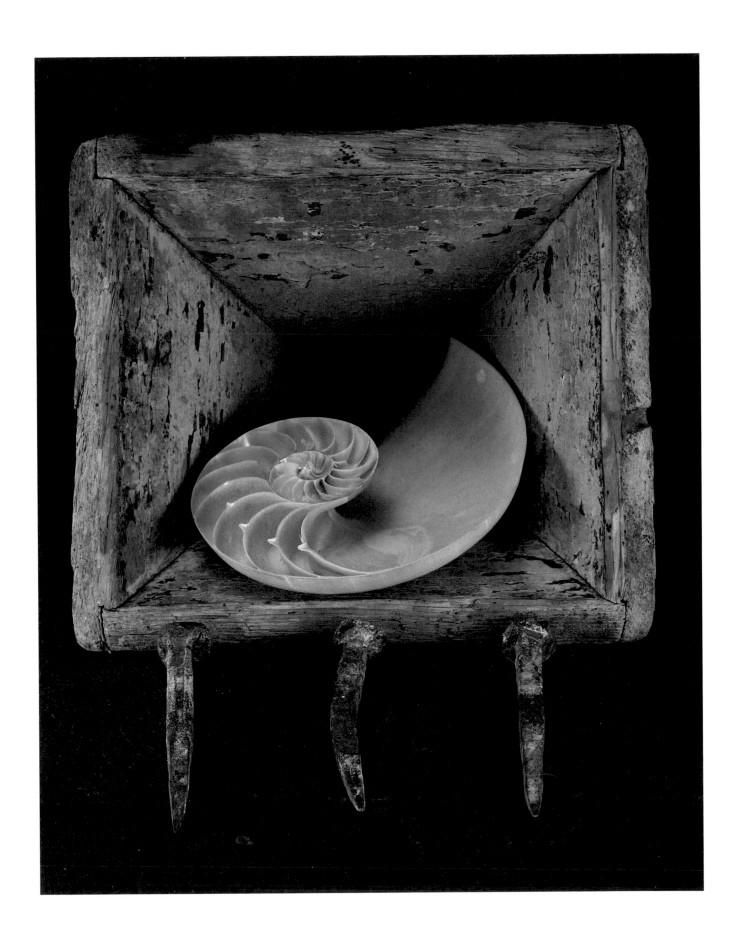

CHAMBERS, 1981

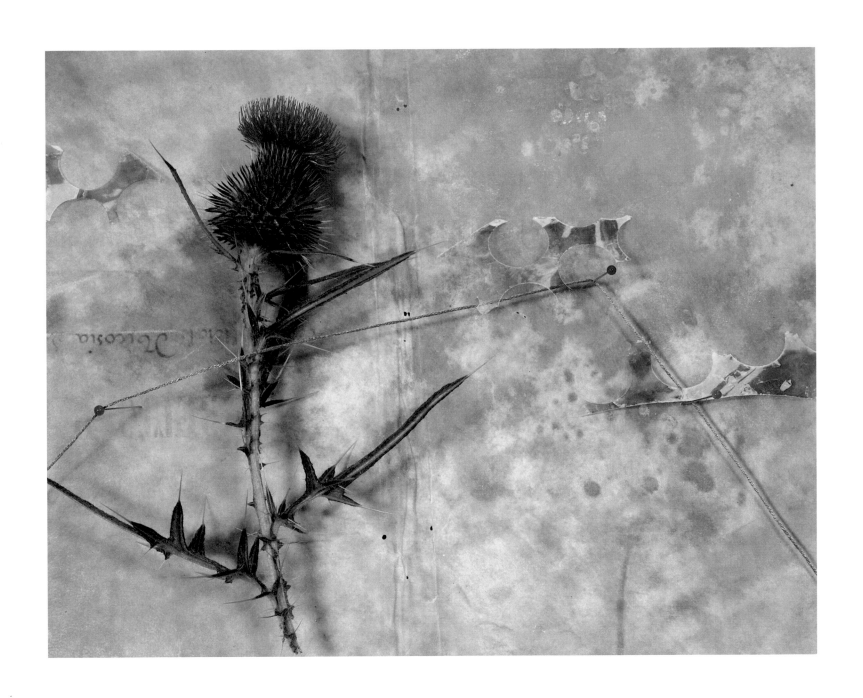

THISTLE, 1982

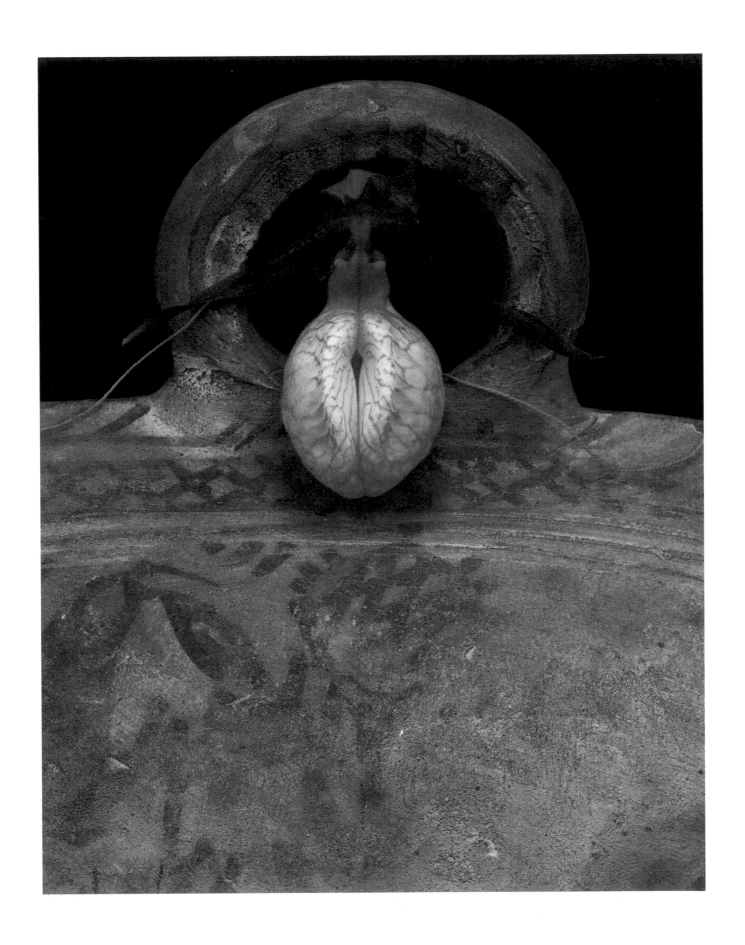

LADY SLIPPER, 1979

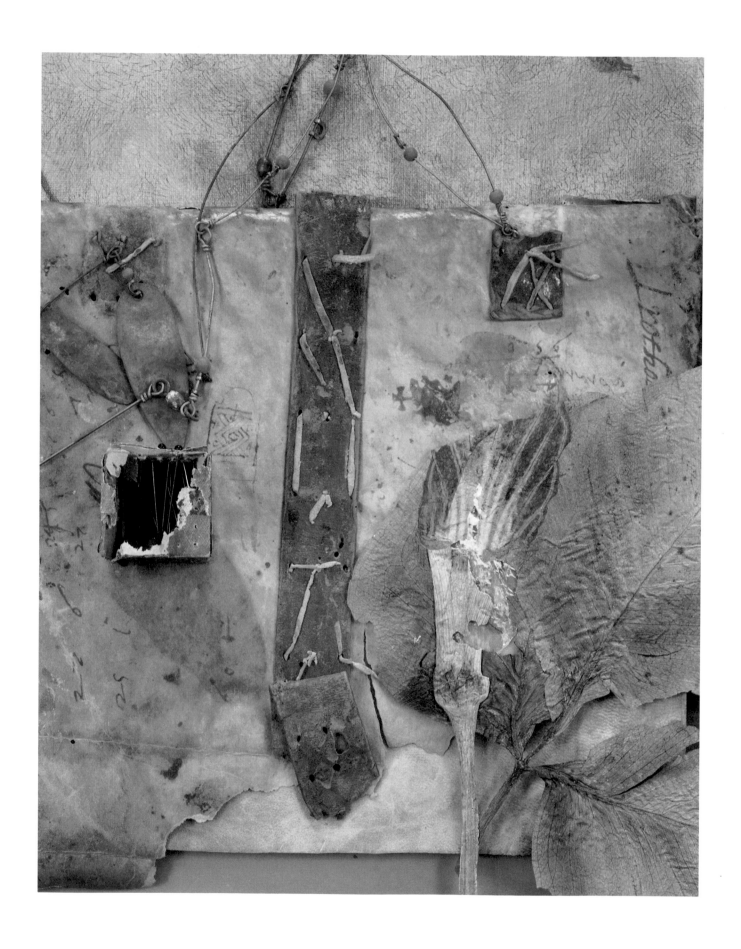

JACK IN THE PULPIT, 1981

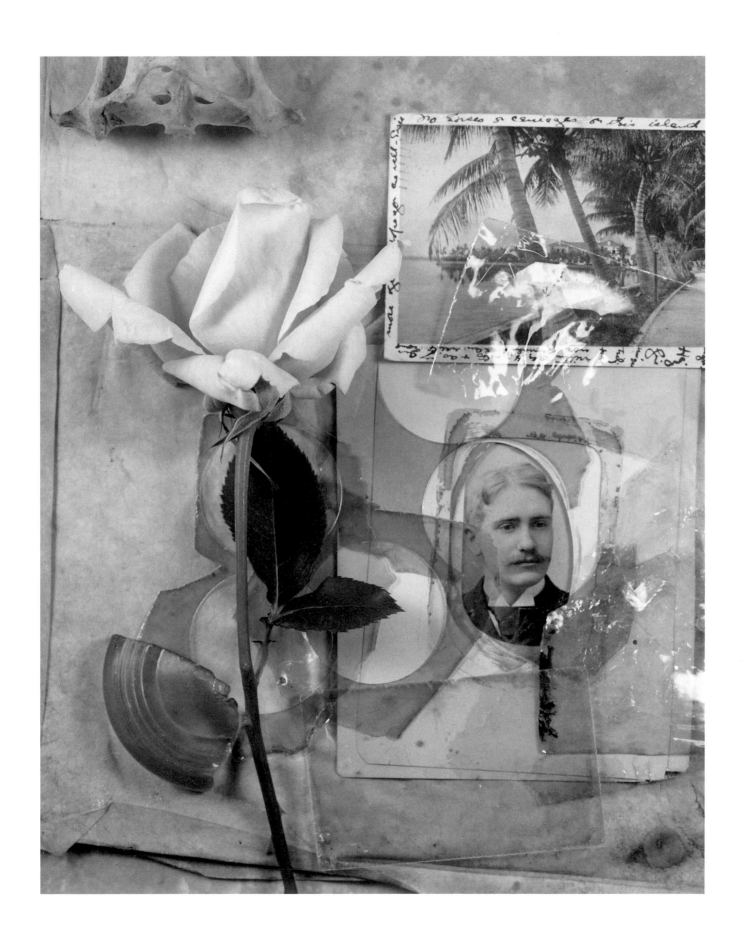

CIRCLES OF MEMORY, 1980

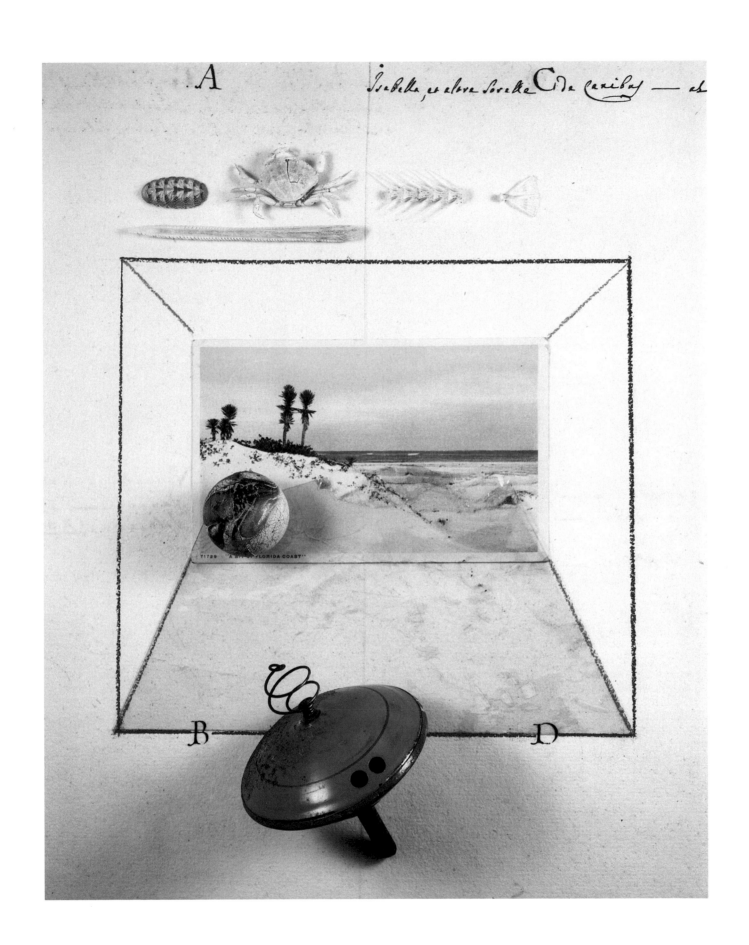

ISABELLA'S BIT OF THE FLORIDA COAST, 1982

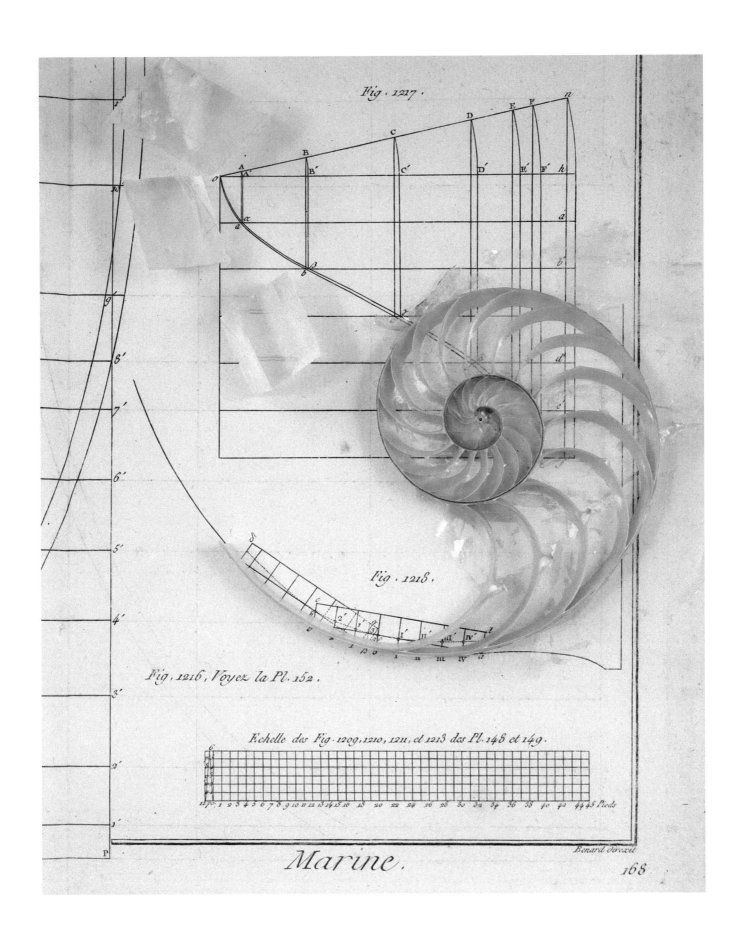

Fig. 1217.

Fig. 1218.

Fig. 1216, Voyez la Pl. 152.

Echelle des Fig. 1209, 1210, 1211, et 1213 des Pl. 148 et 149.

Marine.

168

MARINE II, 1981

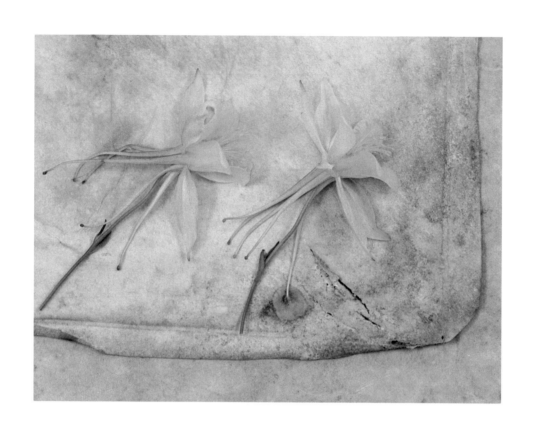

COLUMBINE, 1980

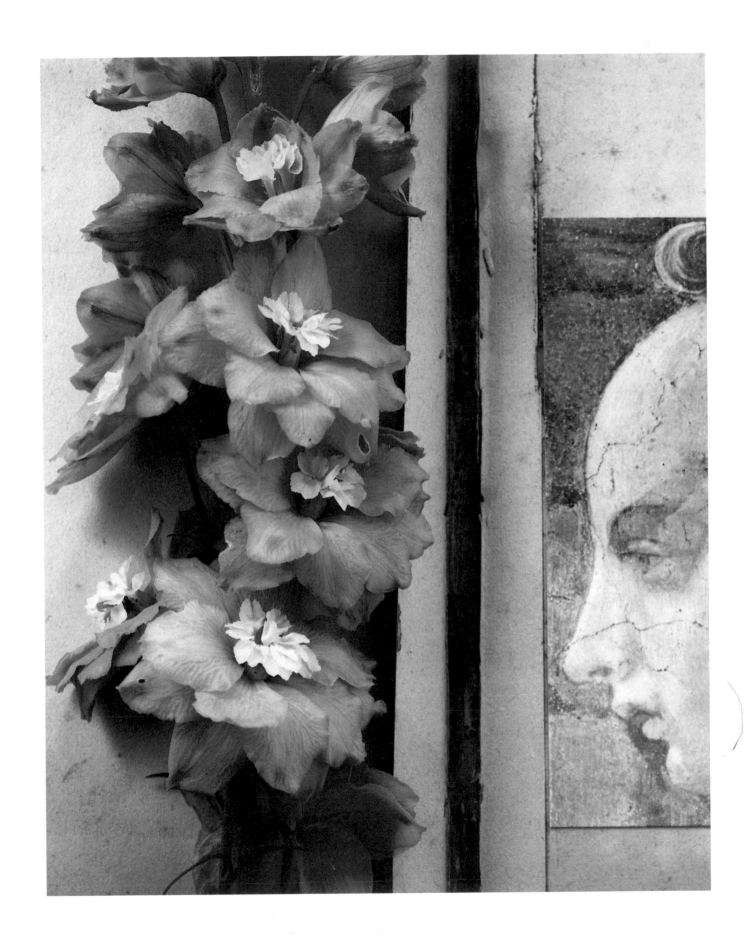

HYBRIDS, 1978

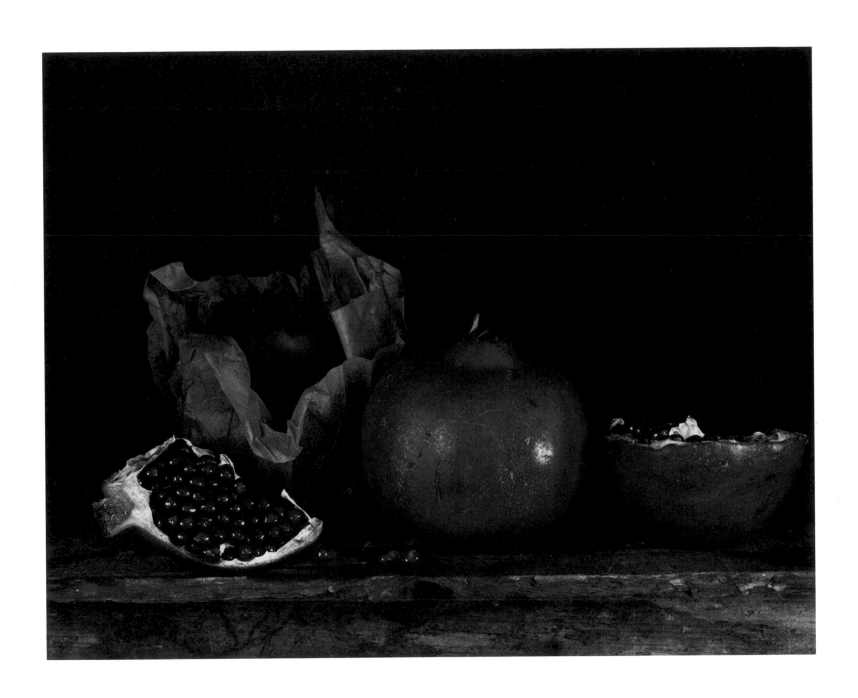

POMEGRANATES, 1979

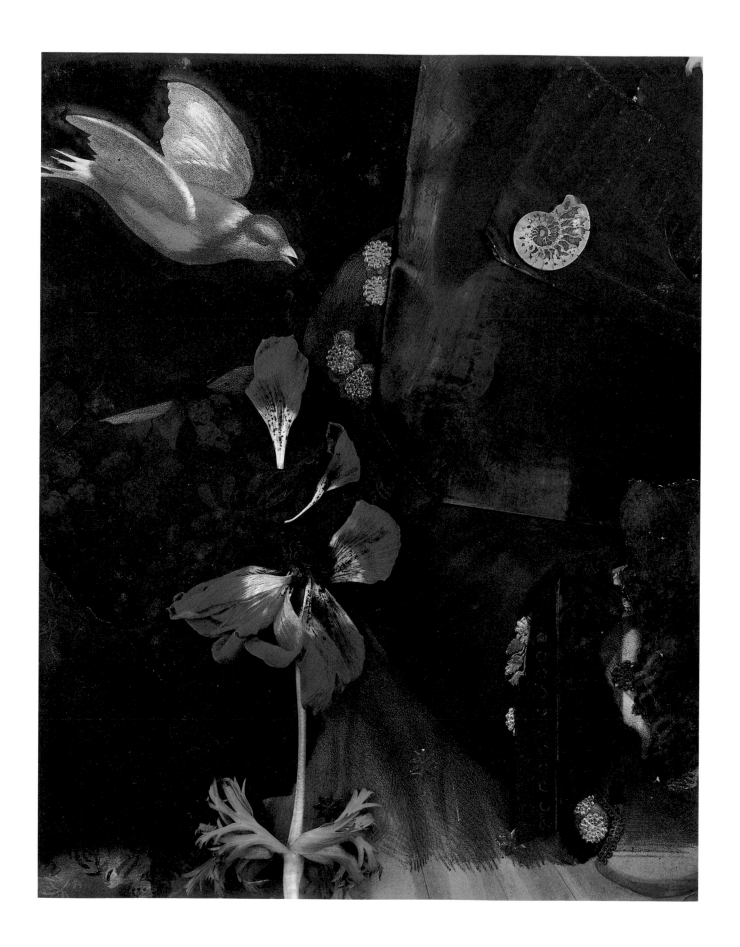

NIGHT BIRD, 1980

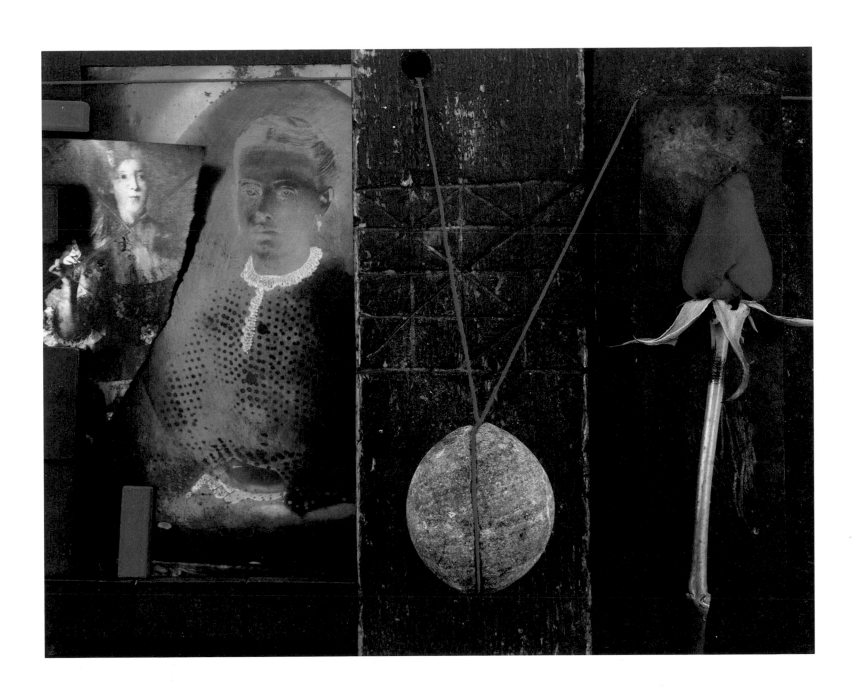

GRAVITY, 1982

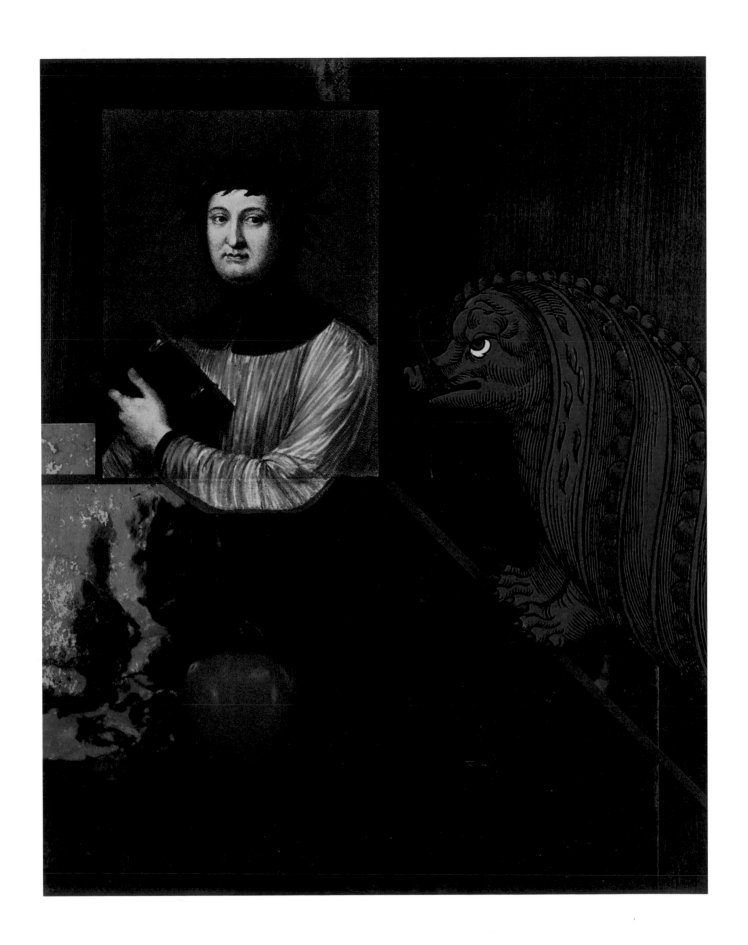

A REASONABLE ARGUMENT, 1980

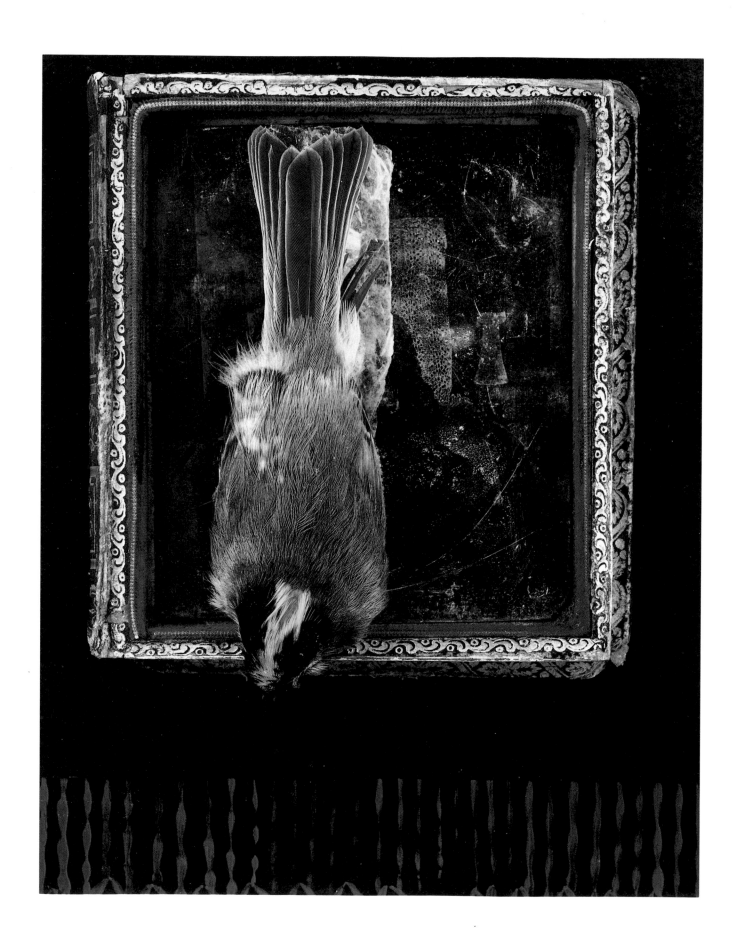

KINGLET, 1979

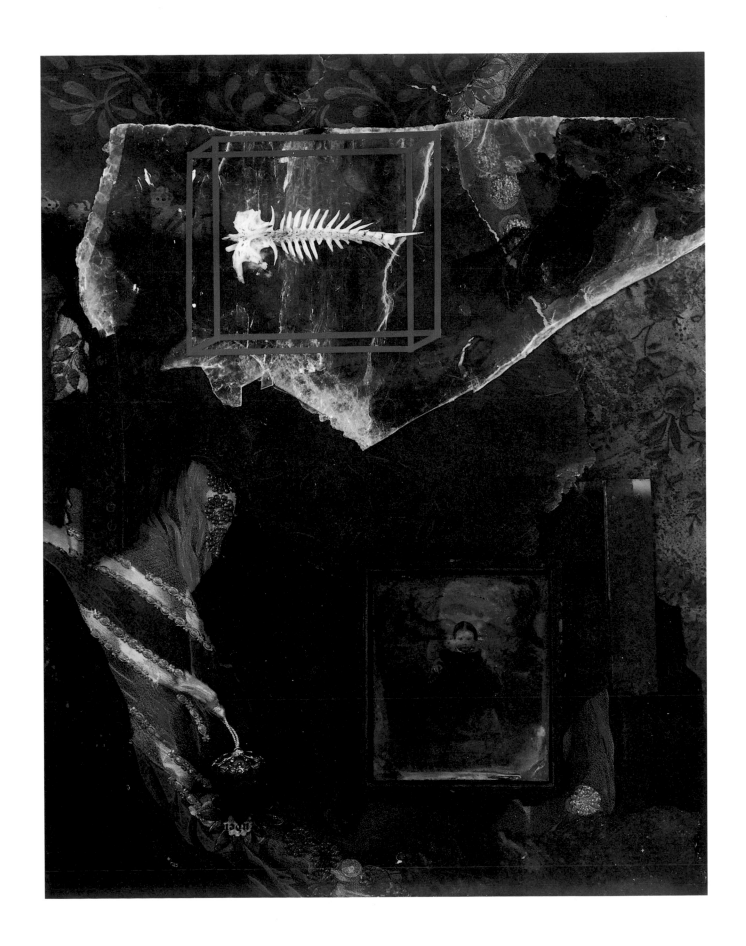

RED CAGES, 1980

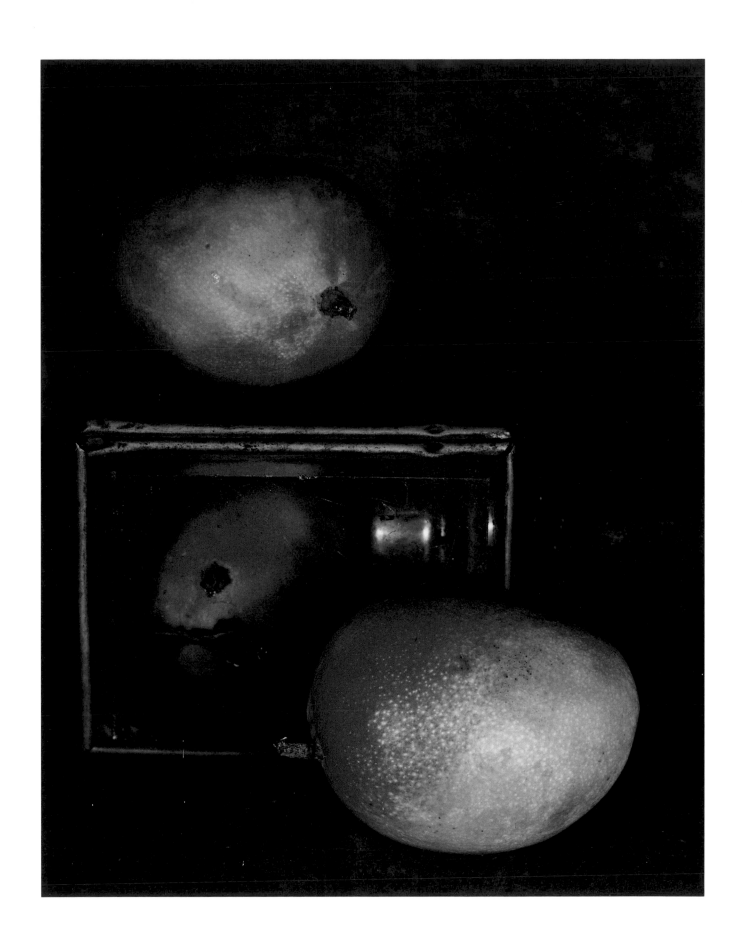

MANGOES, 1978

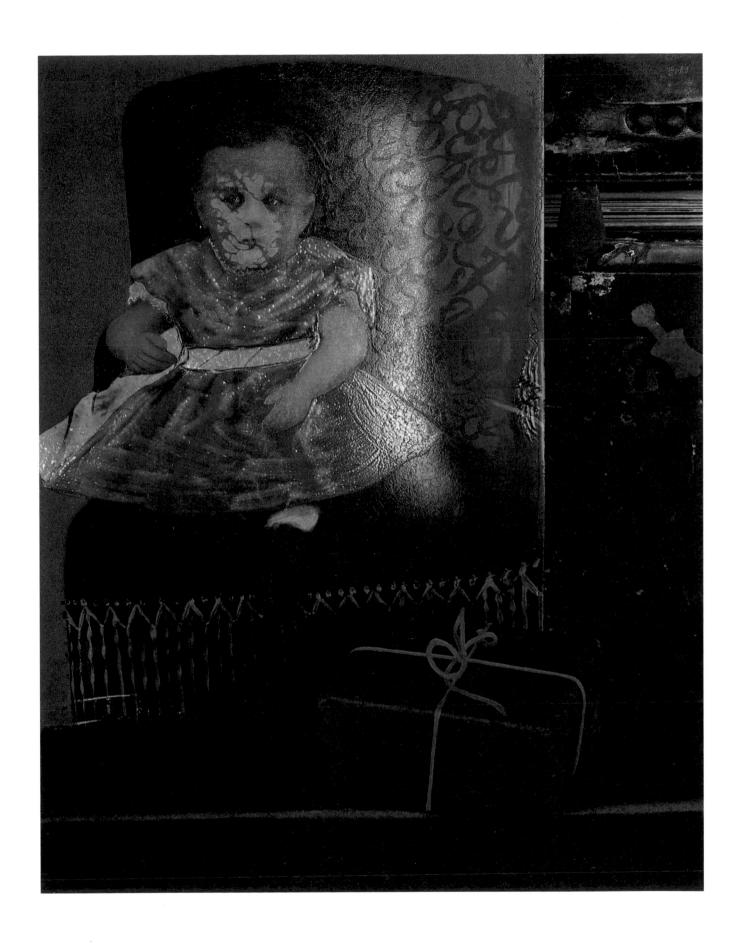

THE BLACK PACKAGE, 1980

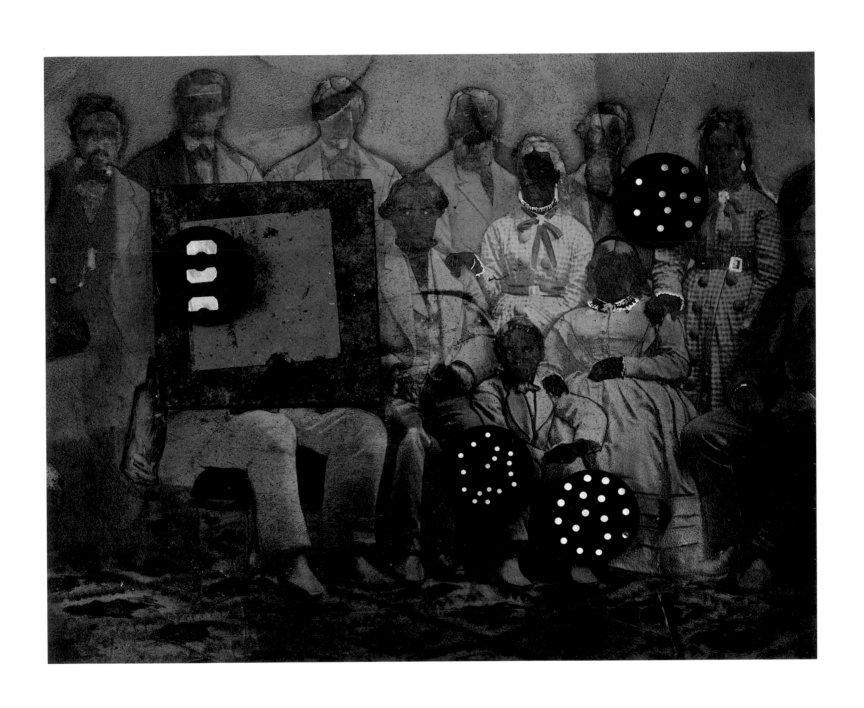

STARLIGHT GAME, 1981

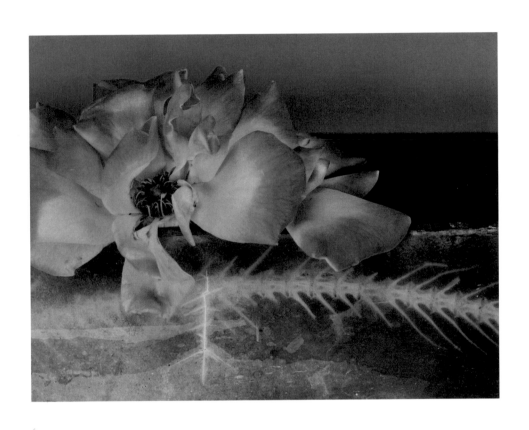

ENDING, 1980

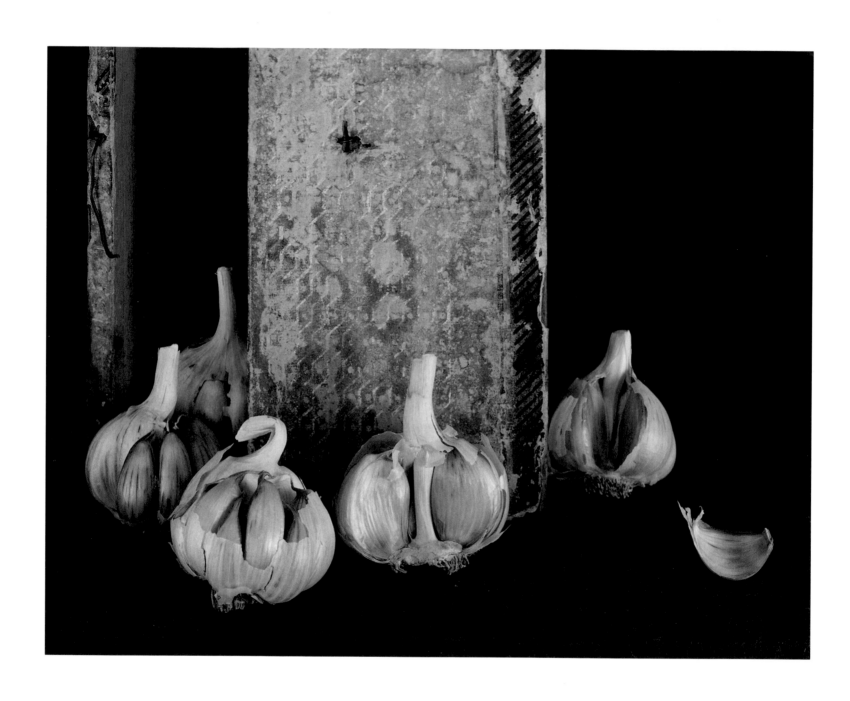

GARLIC, 1981

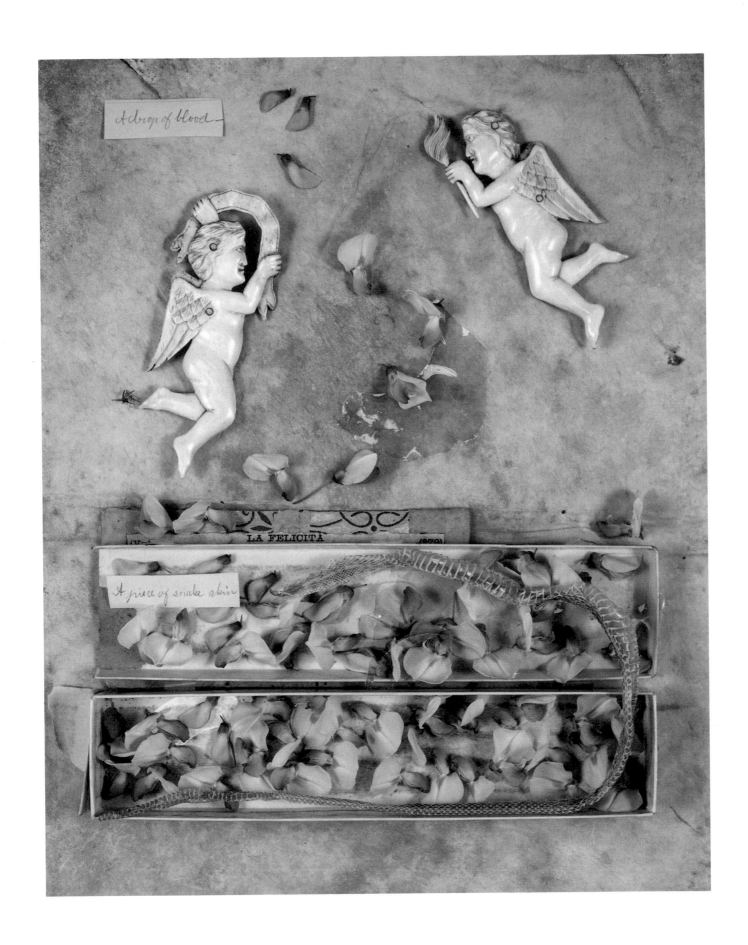

LA FELICITA, 1980

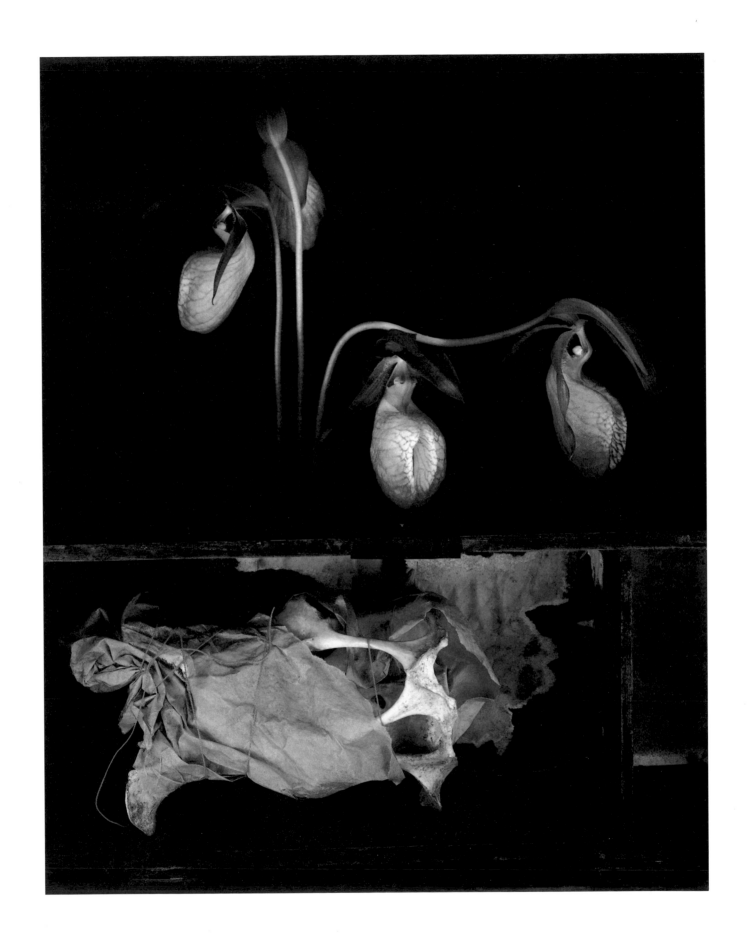

POSSIBILITY, 1979

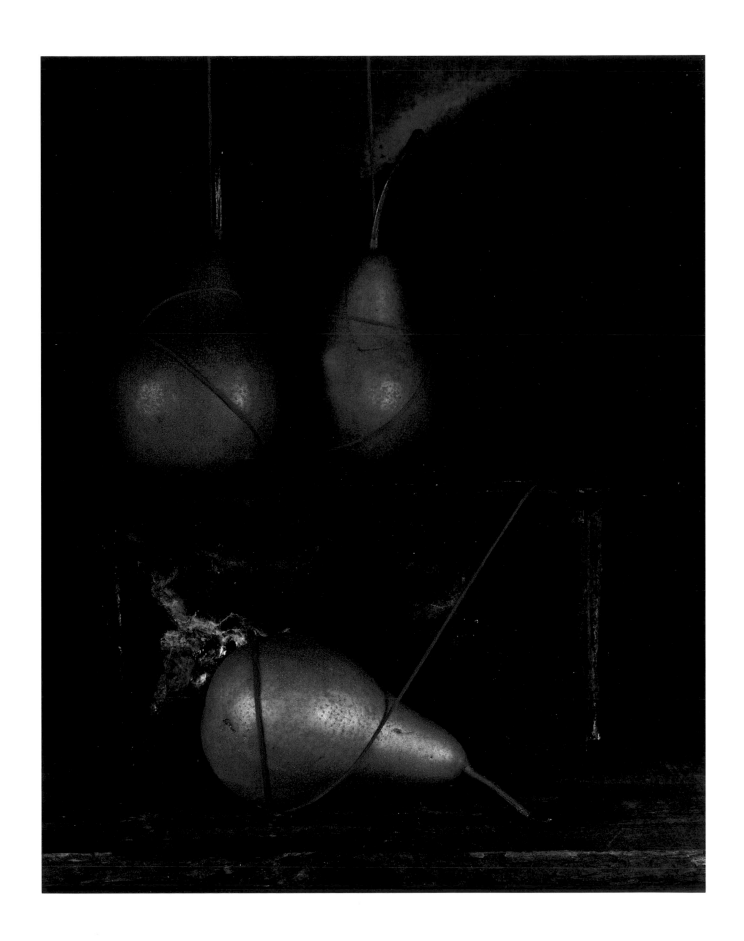

GOLDEN PEARS, 1979

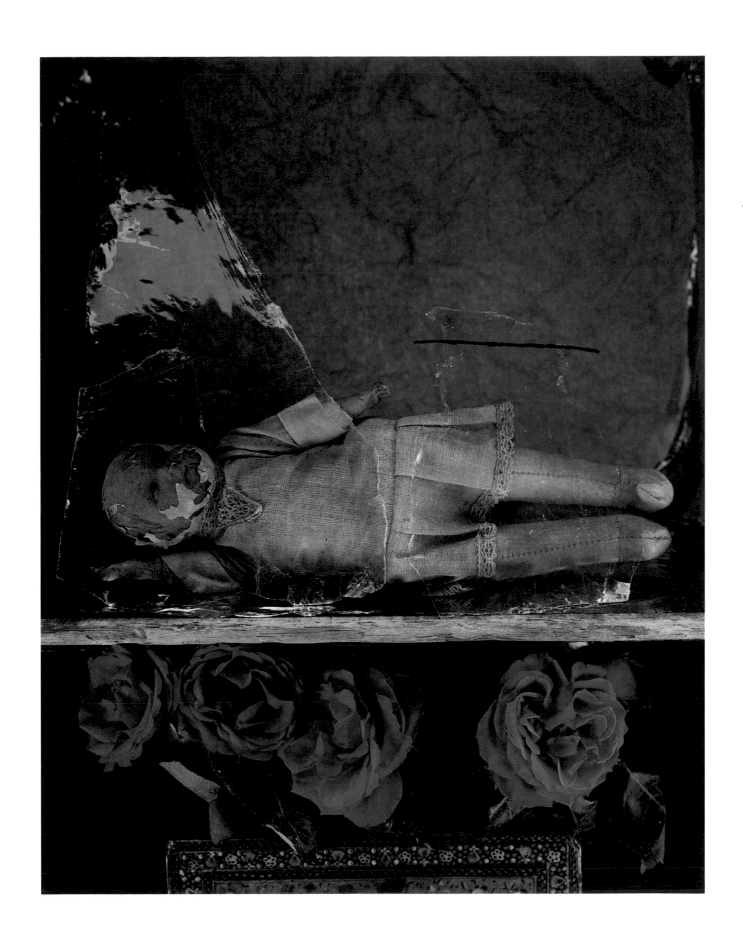

THE EASTERN GARDEN, 1980

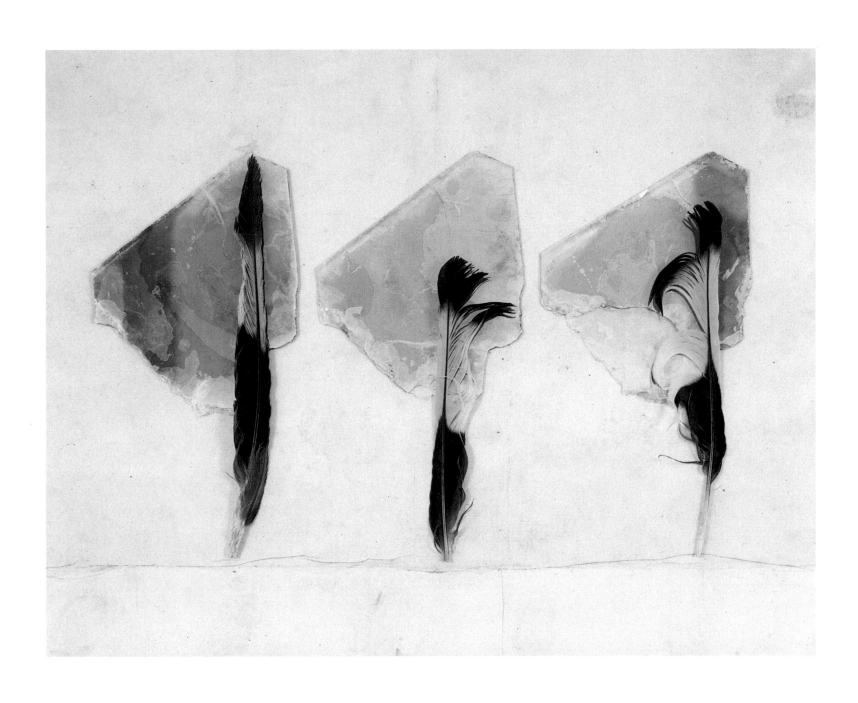

THREE FEATHERS – THREE CRYSTALS, 1981

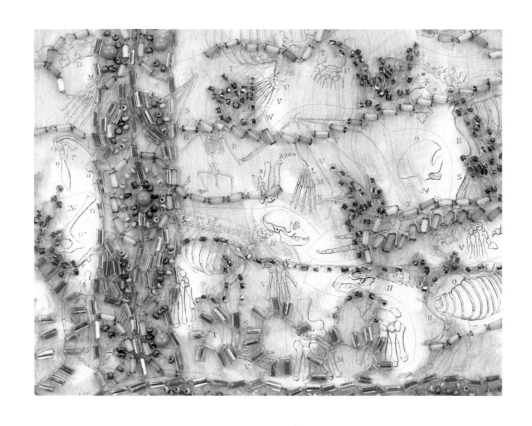

RESIDUE, 1981

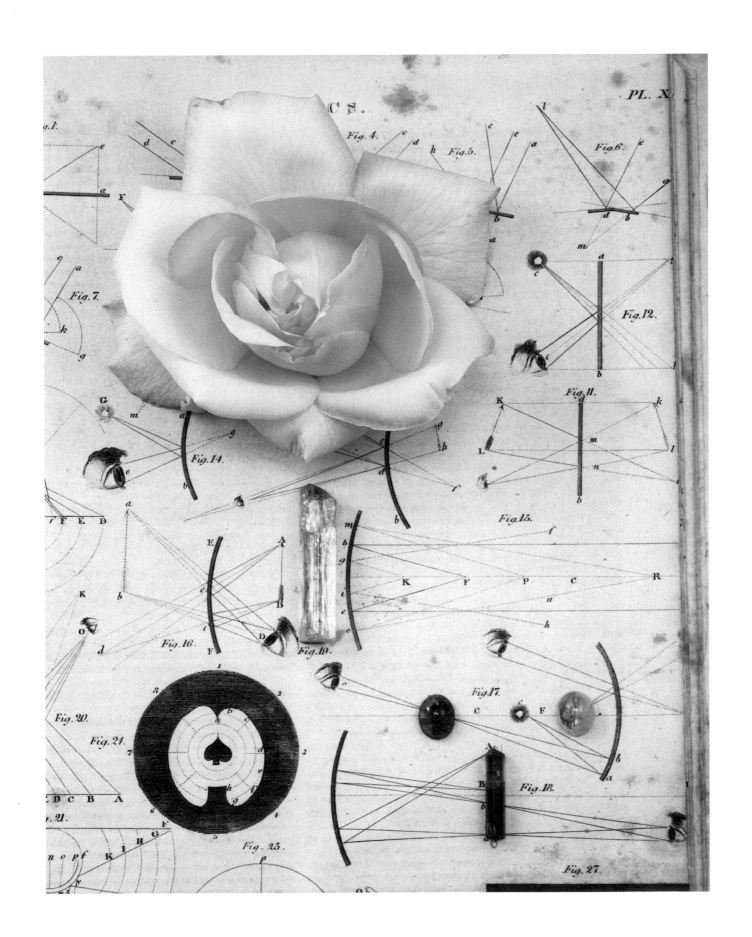

CONTACT, 1978

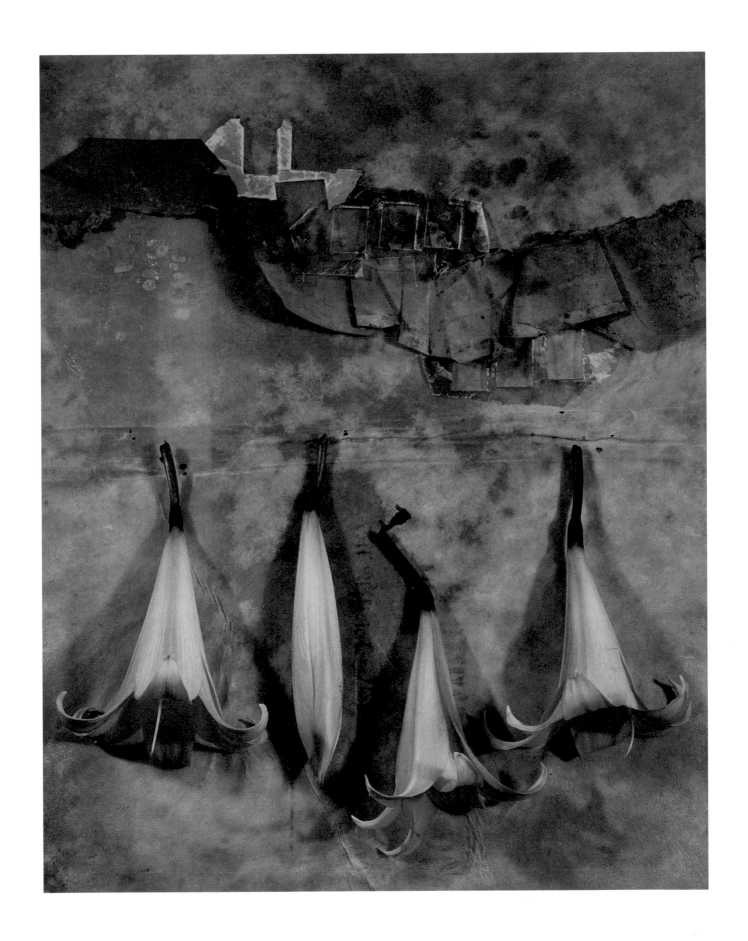

SWAN'S LADIES, 1982

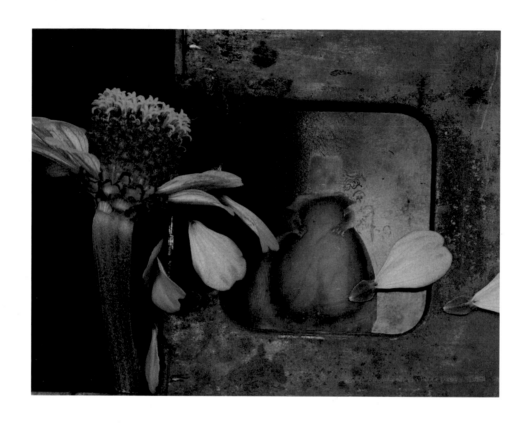

BETWEEN TIME AND ETERNITY, 1980

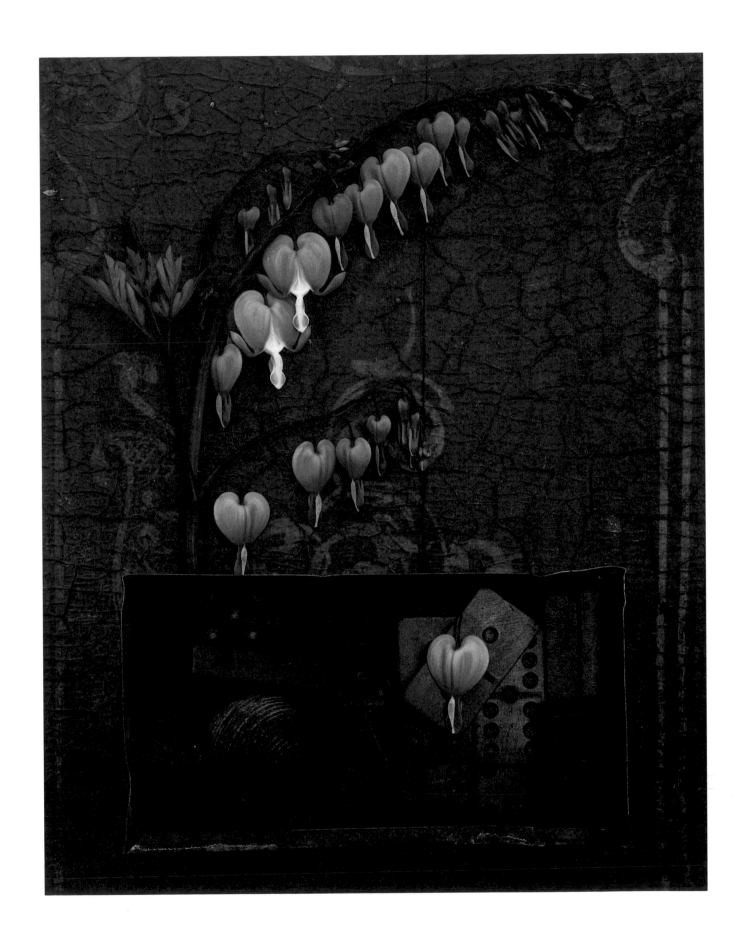

HEARTS, 1980

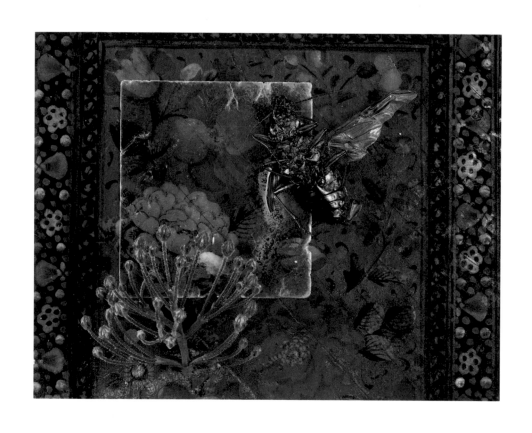

FOR MARIANNE MOORE, 1982

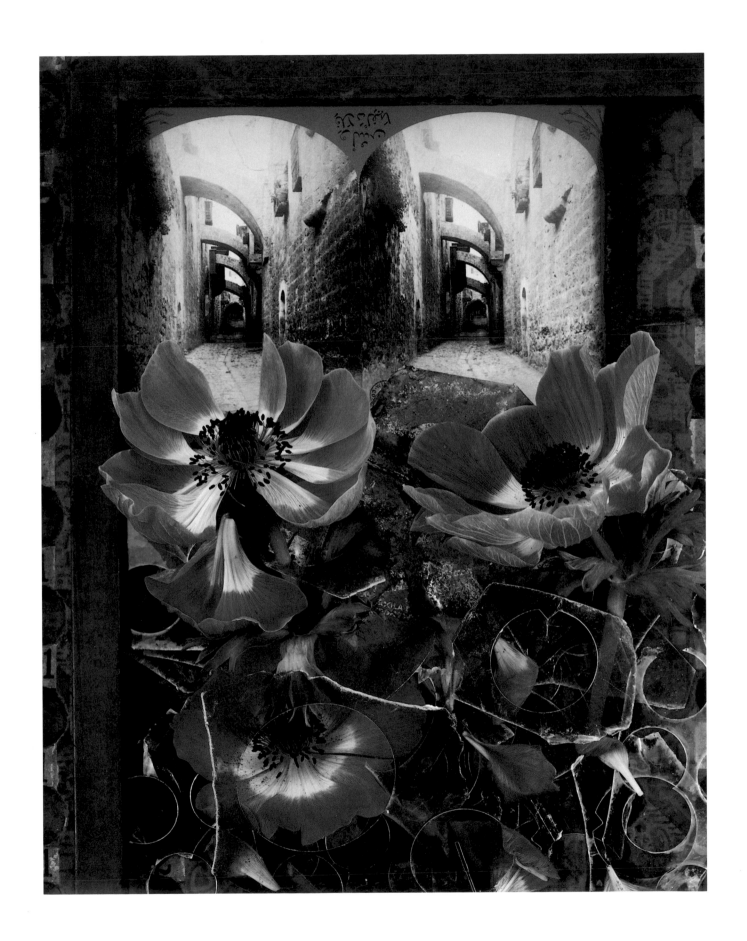

STREET FLOWERS, 1981

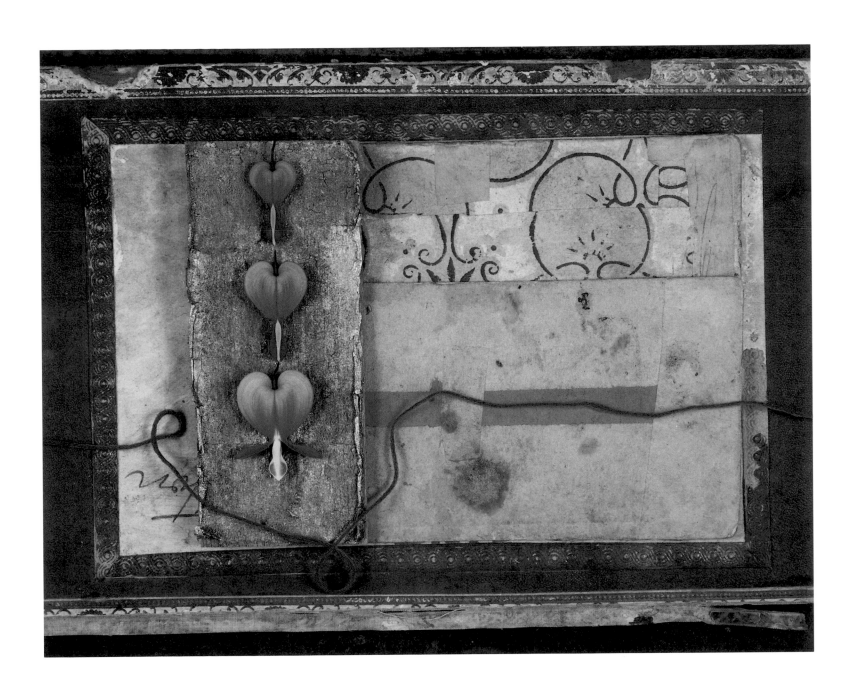

THREE OF HEARTS, 1980

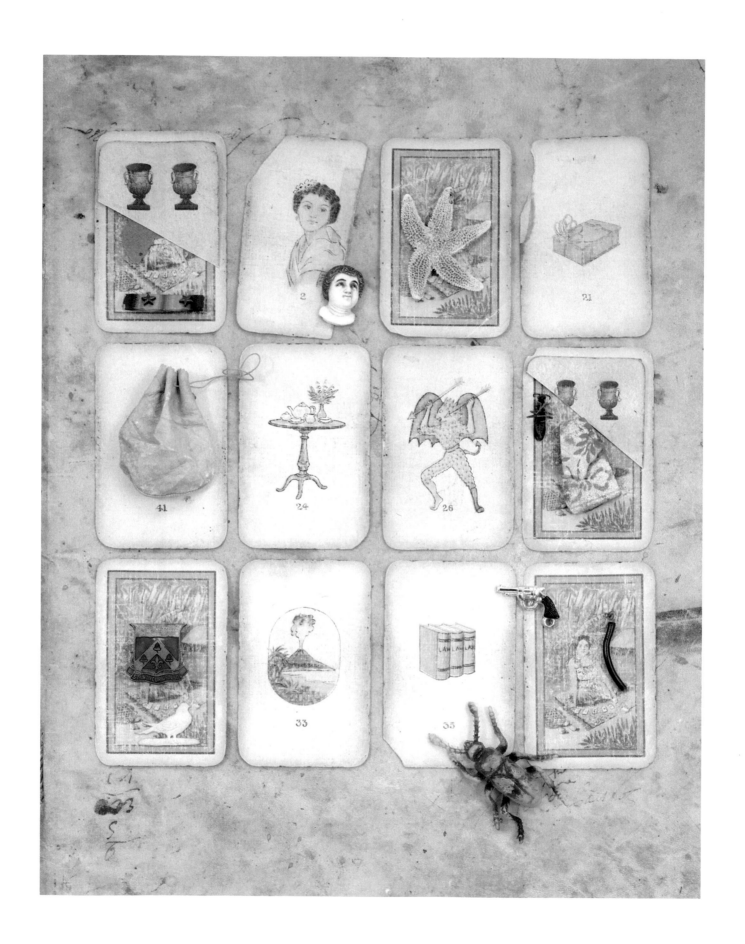

THE DEVIL'S TEA PARTY, 1981

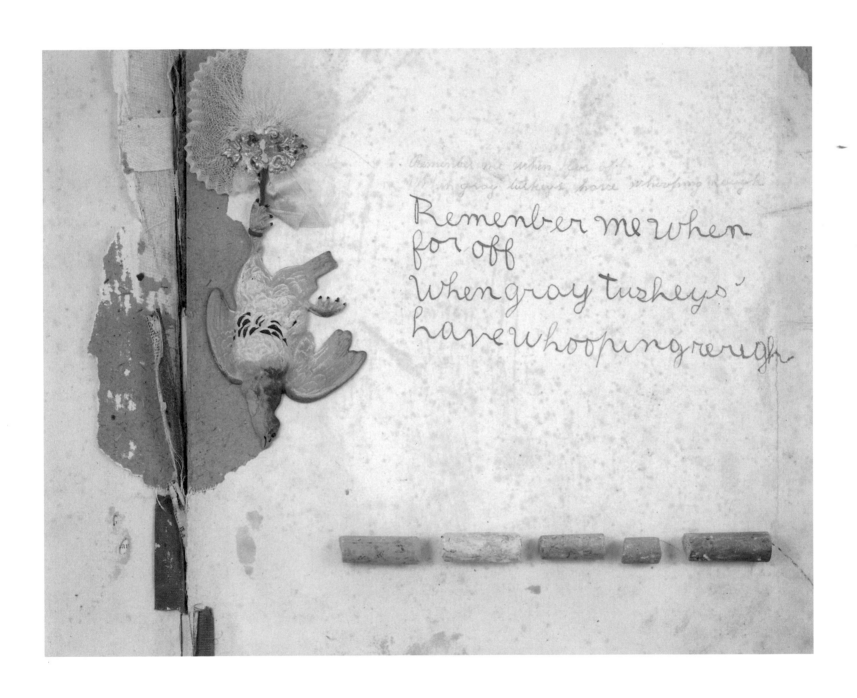

TURKEY SHOOT, 1981

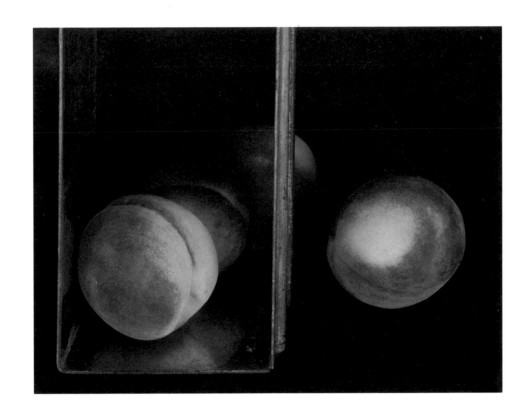

PEACHES, 1980

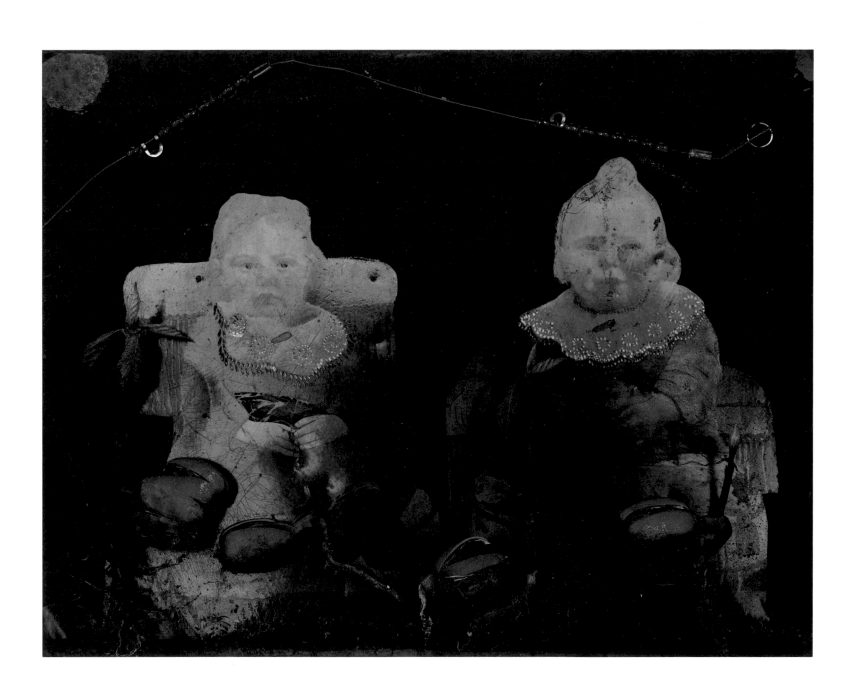

CHILDREN WITH ACORNS, 1981

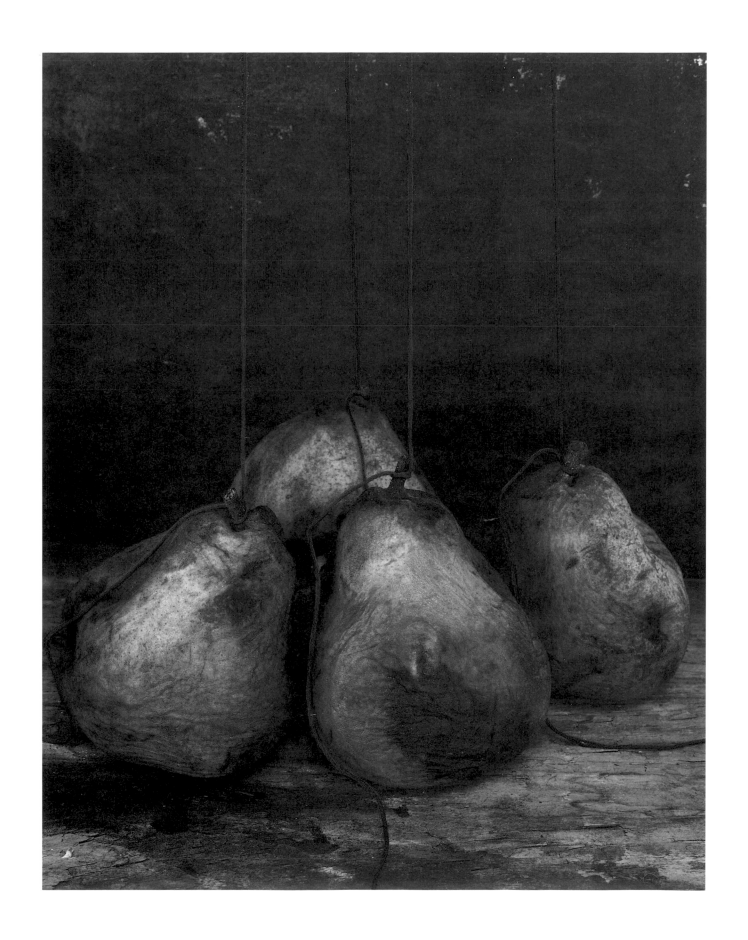

FOUR PEARS, 1979

UNDER THE LOOKING GLASS

was edited by Constance Sullivan

and designed by Katy Homans.

Production was supervised by Robert McVoy

and coordinated by Abigail Potter.

The book was printed by Acme Printing Company, Medford, Massachusetts,

and bound by A. Horowitz and Sons, Fairfield, New Jersey.

The type, Monotype Dante, was set by

Michael and Winifred Bixler, Boston, Massachusetts.

The photographs are on Polaroid Polacolor 2 8x10 Land Film Type 808,

Polaroid Polacolor ER 8x10 Land Film Type 809,

and Polaroid Polacolor ER 4x5 Land Film Type 59.

779 Parker, Olivia

Under the looking glass.